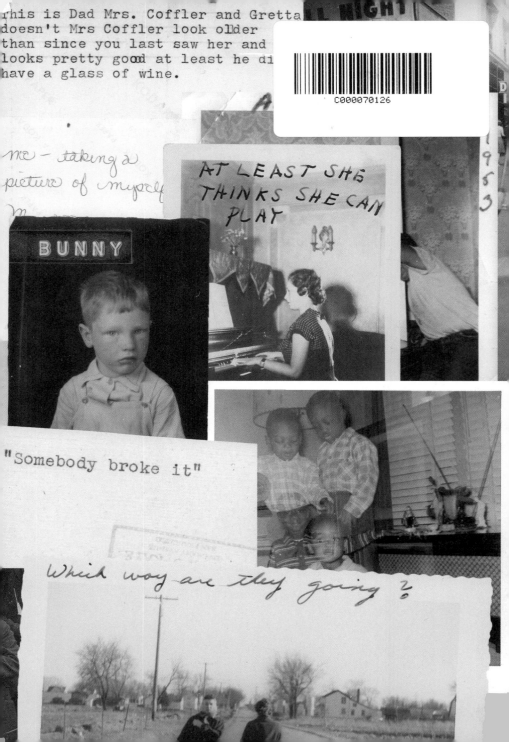

This is Dad Mrs. Coffler and Gretta
doesn't Mrs Coffler look older
than since you last saw her and
looks pretty good at least he di
have a glass of wine.

*me – taking a
picture of myself
m*

AT LEAST SHE
THINKS SHE CAN
PLAY

1953

BUNNY

"Somebody broke it"

Which way are they going?

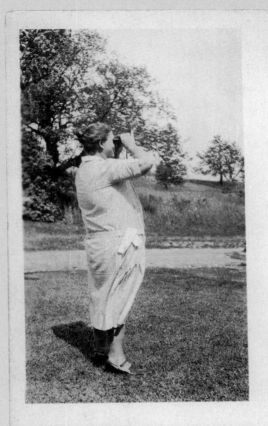

Looking into the future.
What do you see?

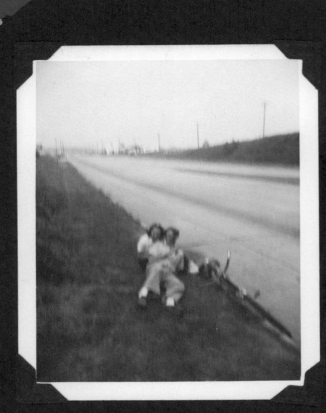

Who Shook The Camera?
Pete.
May, 1943

Caption *This*

A photographic
collection of
AMUSING *comments,*
SNARKY *asides,*
and
ROMANTIC *admissions*

BARBARA LEVINE &
PAIGE RAMEY

PA PRESS

PRINCETON ARCHITECTURAL PRESS
NEW YORK

PUBLISHED BY
Princeton Architectural Press
A division of Chronicle Books LLC
70 West 36th Street
New York, NY 10018
www.papress.com

EDITOR: Jennifer N. Thompson
DESIGNER: Martin Venezky

Library of Congress Cataloging-in-Publication Data

Names: Levine, Barbara, 1960– author. | Ramey, Paige, author.
Title: Caption this : a photographic collection of amusing comments, snarky asides, and romantic admissions / Barbara Levine, Paige Ramey.
Description: New York : Princeton Architectural Press, 2023. | Summary: "A celebration of a century of personal photo captions in all their forms, themes, and voices" —Provided by publisher.
Identifiers: LCCN 2022060352 (print) | LCCN 2022060353 (ebook) | ISBN 9781797223346 (hardcover) | ISBN 9781797226927 (ebook)
Subjects: LCSH: Photograph captions. | Photographs—Humor. | Levine, Barbara, 1960—Photograph collections. | Photographs—Collectors and collecting. | Photographs—Private collections—United States.
Classification: LCC TR147 .L48 2023 (print) | LCC TR147 (ebook) | DDC 770—dc23/eng/20230119
LC record available at https://lccn.loc.gov/2022060352
LC ebook record available at https://lccn.loc.gov/2022060353

Hurry uP, EAT

First and Last Words

BARBARA LEVINE
PAIGE RAMEY
with
PETER L. STEIN

WE ARE ALL FAMILIAR WITH THE SAYING "A picture is worth a thousand words," and yet we seem to have an instinctual need to annotate photographs with captions. With a word or phrase or paragraph, a caption flexes its muscles in front of an unsuspecting photo, taking on a variety of upstaging roles: it can label and describe; it can comment and contextualize; it may excuse, enthuse, criticize, or deface.

The urge to comment on the pictures of our lives seems deeply rooted in the human psyche. As longtime collectors and curators of vernacular photography, we have firsthand experience with this urge and phenomenon. We share our vast archive of found photographs on Instagram with a sizeable community every day, and each time we do, we're tasked with the challenge of coming up with a caption that will help frame the photographs, provide information, start a conversation—sometimes all three. We're not alone, of course: social media users upload approximately 3.2 billion images a day, and they are all thinking about the exact same thing.

We've noticed that when we share a photograph that is *already* accompanied by a handwritten caption scrawled on the image, something interesting happens: followers become particularly energized, often engaging, commenting, and sharing (and sometimes adding their own caption to the caption).

We all find captions captivating, and for good reason; even the simplest ones can be irresistible and persuasive. The extra layer of information and context—whether penned on the original image or digitally applied years later on social media—offers the opportunity to re-experience the image, to overlay new data on what we thought we knew. In the photograph below, someone handwrote,

"Not my Baby." **(FIG 1)** Three words in blue ballpoint ink control the narrative: we now experience the photograph through a different lens than the one that captured the image.

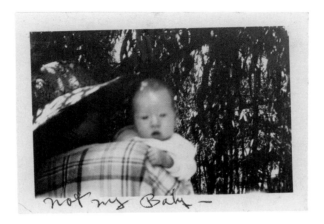

Or this image, **(FIG 2)** which reads one way if you disregard the caption and focus solely on the image, and a different way if you experience the text in relationship to the photograph. The caption becomes a conversation not only with the photo but also with you, the viewer.

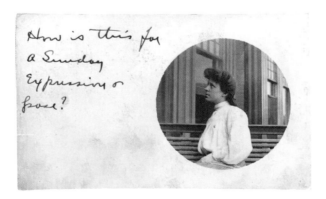

Like these images, the photographs collected in this book, all from the twentieth century, include captions emblazoned beneath, lurking behind, or even scrawled across photos. While an image may have its own message to communicate from photographer to viewer in its bespoke visual language, an accompanying caption is an intervention, inserting itself into the scene or gossiping from the sidelines. The caption is not merely incidental or optional: it insists on being the last word, one-upping the photograph with a textual exclamation point. Captions can be funny or poignant, informative or mysterious, but they can rarely be ignored.

WHY DO PHOTOGRAPHS invite this kind of written commentary, to the point that captions are as worthy as the images and deserve to be collected, appreciated, and showcased? Other forms of visual expression—paintings, murals, sculpture—occasionally attract textual comments as a kind of appendage, but they are usually in the form of a detached, and detachable, piece of information (think museum labels), or an incident of unwanted vandalism (think graffiti). But handwritten captions on photographs seem inextricably part of the work itself, indivisible, part of the experience of the underlying image. This is due, in part, to the nature of the modern photograph: as a miniaturized record of daily life, photos allow us to interact with them on a human scale in a way that no other medium can approach. When we hold a physical photograph in our hand, the scene becomes recognizable and relatable and often invites a personal response—in the same way that in the privacy of our own living rooms we might find ourselves talking back to the television. So the caption becomes a record and an amplifier of the photo's impact on its original viewer.

Textual additions to photographs seem to have appeared with the very invention of the medium. Albums of daguerreotypes and formal *cartes de visite* would be ornamented by accompanying text displaying, at

minimum, the name of the photography studio or the identity of the sitter. **(Fig 3)**

As photography has become a more accepted and everyday part of human expression, with its own easily grasped visual grammar and subtext, the allure of textual commentary has only become increasingly more prevalent—as anyone commenting on an Instagram post or participating in an online photo caption contest can attest.

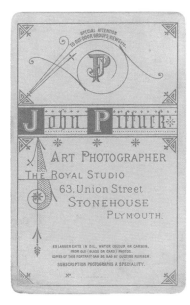

When we think about the function of photo captions, it is often first in the context of their journalistic utility, deployed by a magazine or newspaper editor to provide anecdotal information not otherwise available in the image: a subject's name, a geographical identifier. But in the world of personal photography, the caption serves far more than an informational function; in fact, a caption often obfuscates or undermines the visual information conveyed in the photograph. Strictly informational captions (name, place) try to convey a kind of objective permanence to the photograph: "This is a record of a person," "This place exists." But personal captions are anything but objective: they insert an editorial voice into the act of viewing a photograph that was not present when the photograph was made.

This triangulating nature of a caption—introducing a third party between the viewer and the photograph—is what makes viewing captioned photographs an especially dynamic, surprising, and sometimes even destabilizing experience. The viewer must contend with a competing point of view to their own: a photograph may appear one way to the viewer, but a caption can contradict that

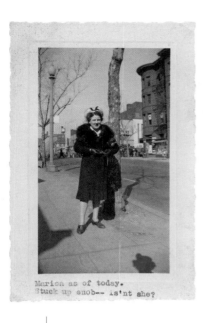

Marion as of today.
Stuck up snob-- is'nt she?

4

impression ("Stuck up snob—is'nt she?") or radically alter the experience of the photograph with a telling piece of information ("We had such a 'good' time—until Isabel and Pete fell overboard"). (FIGS 4, 5)

These textual aspects of the viewer's experience of the photograph challenge the visual experience and engage the viewer in a three-dimensional balancing act: apprehending the photograph itself (the literal information), the emotional impression conveyed by the image (one's unilateral affective relationship to the photograph), and then—surprise!—the twist introduced by a completely separate voice in the text (the triangulated context).

And yet, as complex as that may seem, captions and annotations are incredibly fun. They turn a mute, one-way relationship between viewer and viewed into a conversation with a stranger: a witty comment, snarky aside, or self-deprecating admission all serve to bring a lively new perspective into the moment. When that voice originates from the photographer or subject herself, captions are like a director's bonus track on a DVD—we get to hear the inside scoop on how or why a photograph came out the way it did ("Flash to Quick"). The caption author inserts herself into the conversation to provide context, humor, or attitude that we couldn't have known or appreciated otherwise. (FIG 6)

But our insistence on commenting on and contextualizing photographs, as borne out in this book's examples, also betrays our underlying insecurity about the nature of photography, and our discomfort with the permanence of imagery. We are often not confident that the impression conveyed by a photograph is going to land

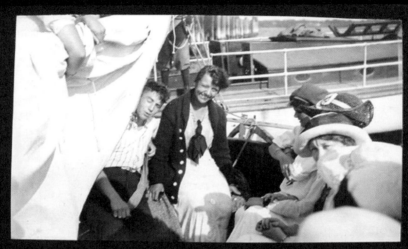

We had such a "good" time - until
Isabel and Pete fell overboard.

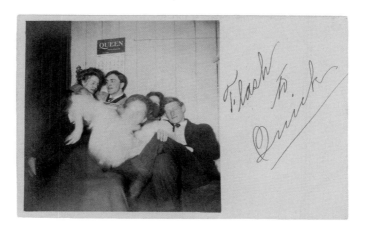

the way we want others to experience it, so the caption is a way of exerting more control over the life of the photograph as it migrates into the world.

"Not my Baby"; "Don't look too long you'll lose your eye sight"; "Terrible"—these additions to the photos say much more about the caption writers than about the photographs themselves. They convey an anxiety about how photographs are shared and seen when we are not there to explain their meaning: Will my intentions be understood if I am not looking over your shoulder while you view it? Is this image subject to multiple interpretations, so that I must spell out in precise language what message I wish to convey? **(FIG 7)**

WHAT IS WONDERFUL ABOUT these analog images and their emblazoned, handwritten captions is that the image and caption are permanently wedded together; the captioner's personality and point of view—conveyed through witty phrasing, distinctive handwriting, or simply the unique quirkiness of a voice—become inseparable from the image. The caption author has become as immortal and permanent as the subject of the photograph.

Today, images posted on social media are our way of curating, framing, and contextualizing our lived experience, but our comments and captions may or may not become detached from the images they describe. Unlike the durable personal photos of the past that could be written on back and front, today's shared digital photographs can easily be separated from the captions that contextualize them, often losing their initial framing and inspiring the new narrator to create their own. The anxiety we have today is reminiscent of what we see in the captions and comments from this much earlier generation of personal photographs, except now it is compounded by a new anxiety: that the caption may not travel the distance with the image as it tumbles through cyberspace.

CAPTIONS OFFER US the chance to feel connected to the strangers who once scrawled those words, a connection that images alone can't provide. In a sense, a caption is both a passport and a portal: with just a few words, an unnamed person becomes familiar, with a sense of humor and a take on life that might remind us of someone we know. Handwritten captions on physical snapshots take us back to a different time. Not necessarily a simpler time—each era has its own complications—but they help us realize that although the clothing might be different in these images, and the cars, too, the compulsion to caption was as real then as it is today on social media. We're living in a digital heyday of captioning, and there has never been a better time to take a fresh look at photos from the past with handwritten captions and consider how we picture and narrate our lives today.

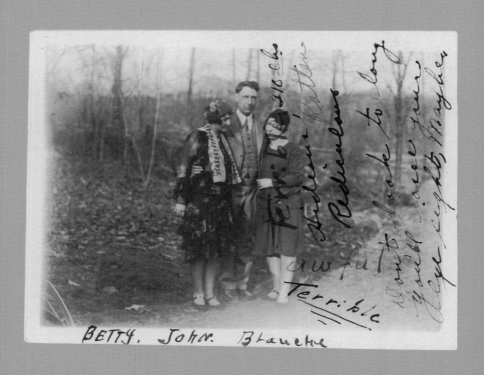

BETTY. John. Blanche

7

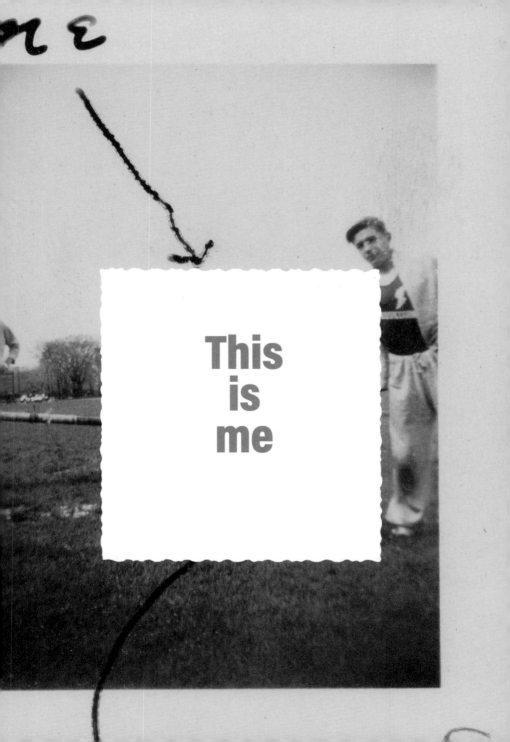

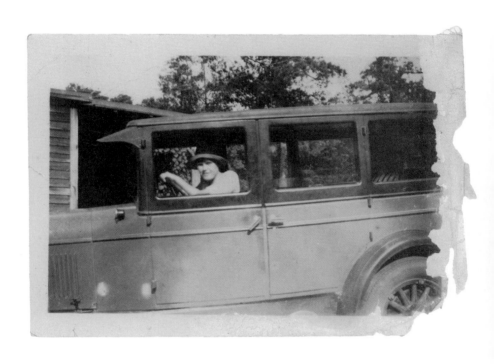

This is me

this is an
outline of
me

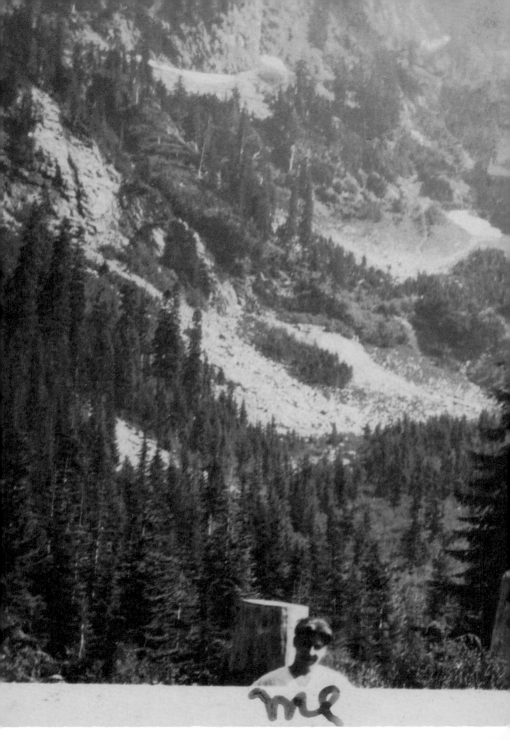

me

Me

Myself

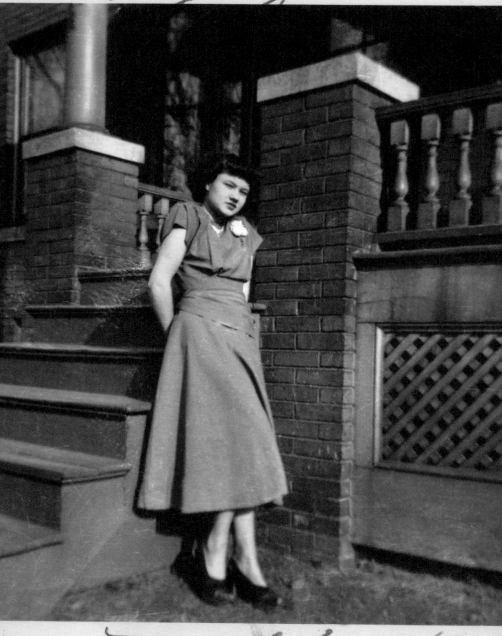

March 6, 1948

This is Hallie and I. Be sure and notice that it is me.

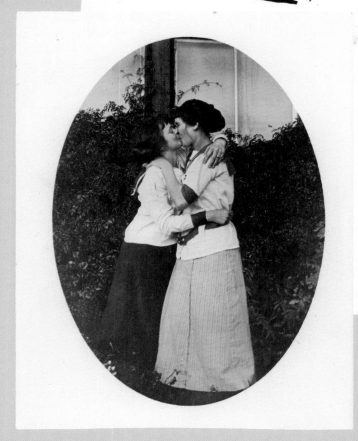

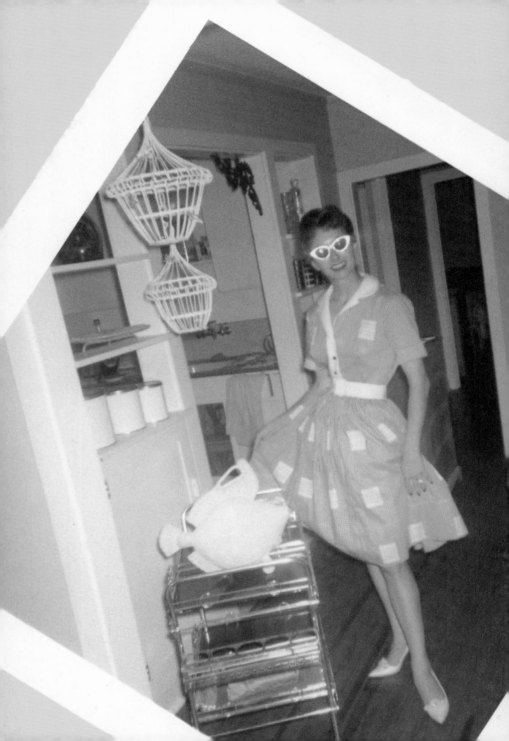

Joline – Age 23 7-61
In new red
dress & white shoes.
Everyones likes
this dress.

Mama and her new permanent.

August, 1968

Cecile you look nice

MALE
MODELS
NOTE FASHION

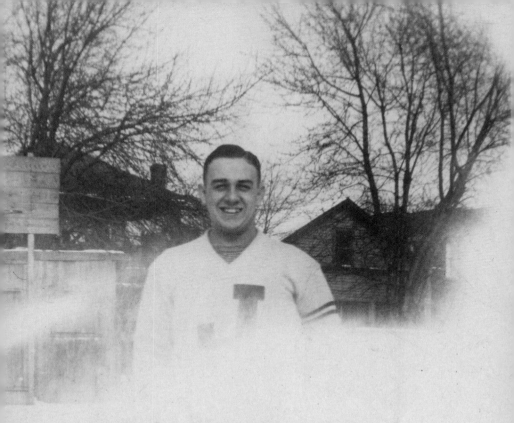

MY INVISIBLE
Pants

Trying to be tough
how do you like
my new hat.

Sept 22
1965
my new glasses

The Black gloves cover the E

~~[illegible crossed out]~~

~~[illegible crossed out]~~

Rolled socks
& everything.
Georgia

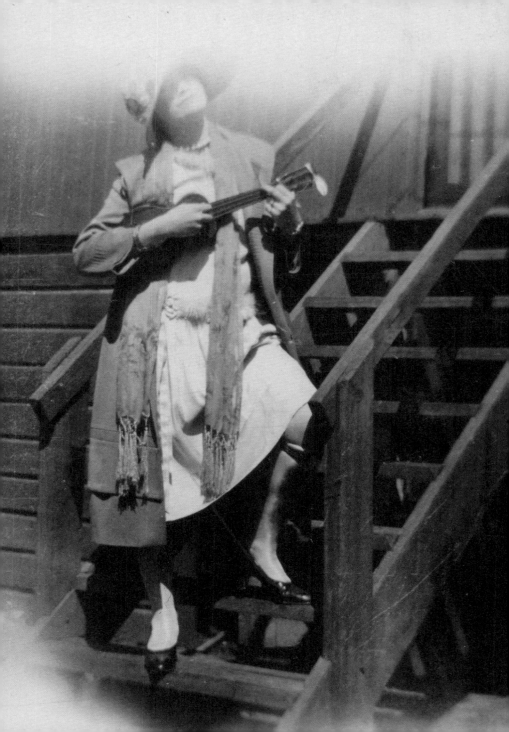

Just me & Kitty.
on the front lawn
I have on my $6 75
dress. Same class.

May 30 - 1926

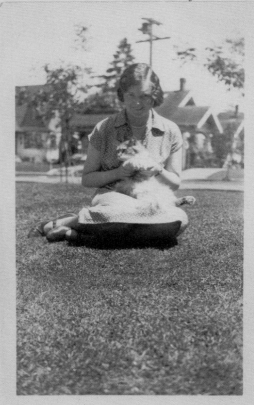

His name is Alice
Note the pants
leg.

AN ORIGINAL POLAROID® LAND PHOTOGRAPH

SUBJECT _trying'p to be Cool_ DATE _____

NAME _Thomas spain_

ADDRESS _Rd. Hast ave._
Milleville

REGULAR SIZE COPIES

WALLET SIZE COPIES

For your convenience
when ordering copies, 5 x 7 ENLARGEMENTS
indicate the number of
copies desired in the 8 x 10 ENLARGEMENTS
appropriate box for the
size(s) you select. 35mm SLIDES
P558A-1 5/70 Printed in U.S.A.

at Sylvian Beach
"Man with bra on."

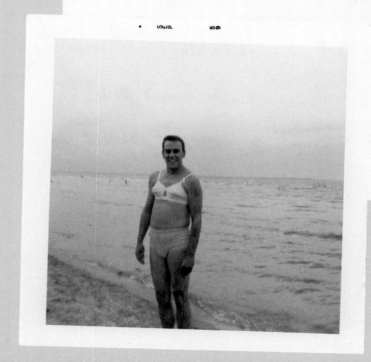

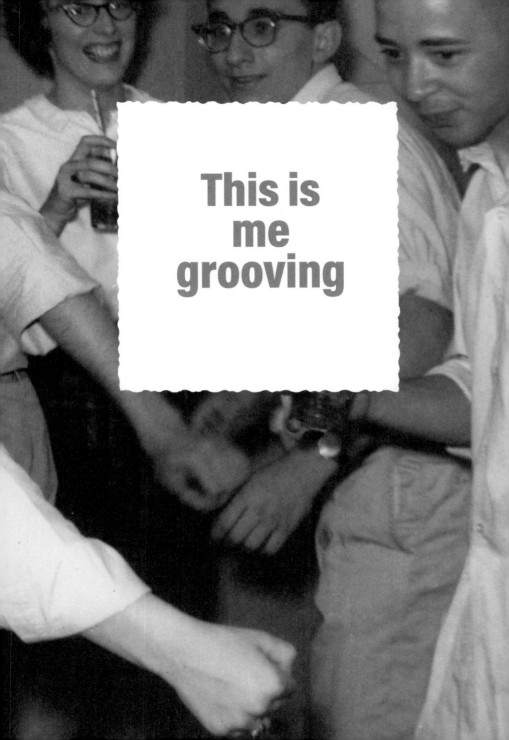

"Tommy Dorsey"
He loves to blow
the horn, no foolin.

885B

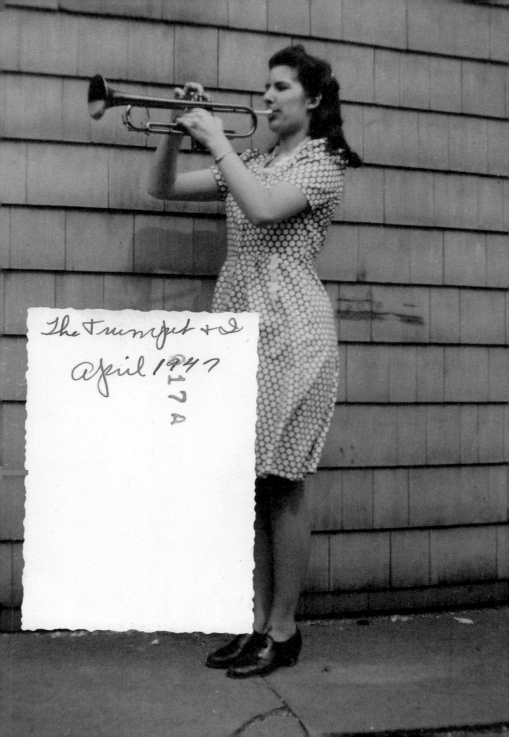

The trumpet + I
april 1947

917A

Ginny,

Lots of luck and
success to a swell
cousin from one "ELVIS"
fan to another.

"ELVIS"

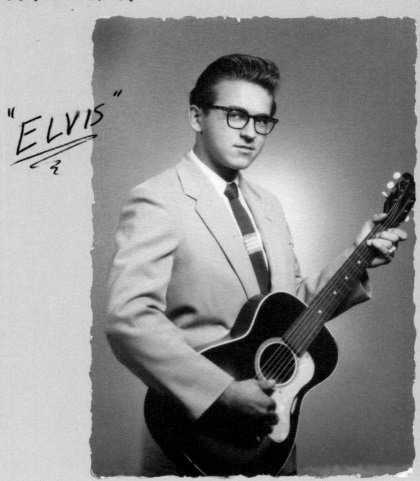

Fordon

yeah — this is me
at the club.

Note the pre-marriage
happiness.

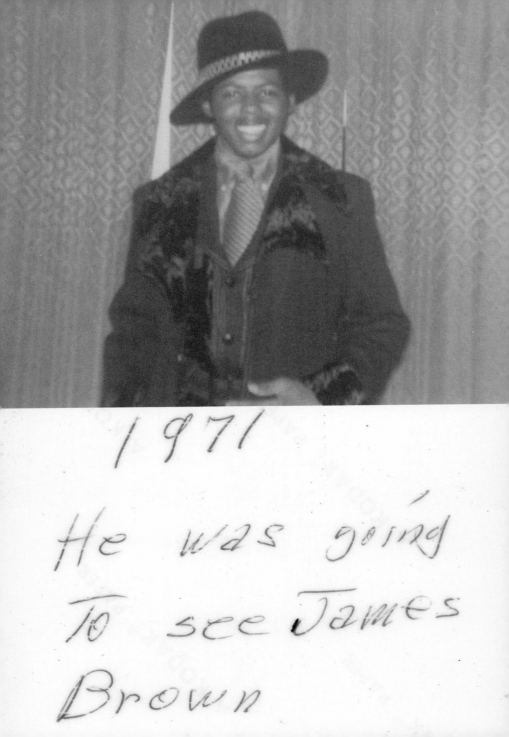

1971

He was going
To see James
Brown

64
"went to set
Jackie Wilson

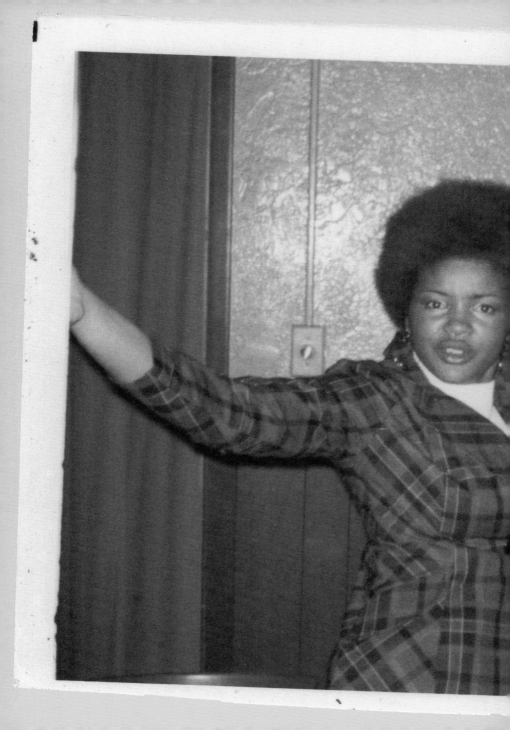

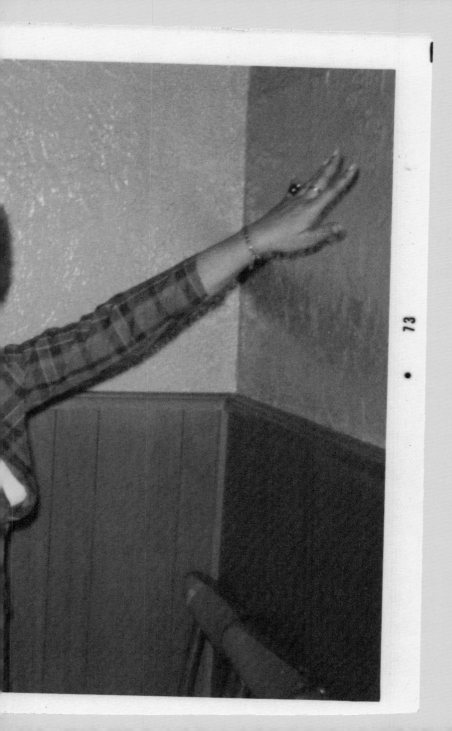

73

GLORIA Trying
To get down
Smile
she look pretty
Good

MOM DOING "CHURNING BUTTER" DANCE WITH
JOHN AND LOIS ~~[illegible]~~

JU

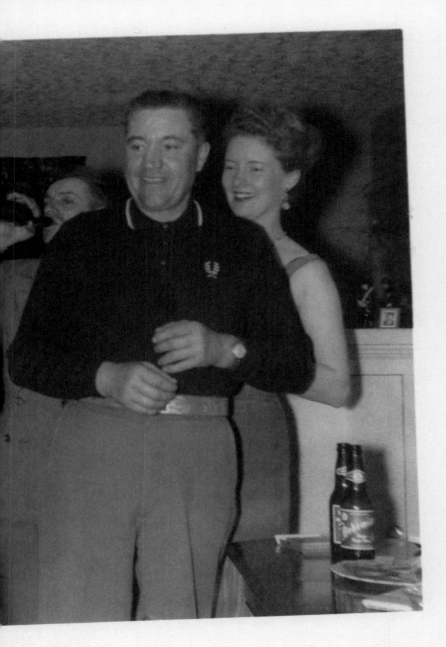

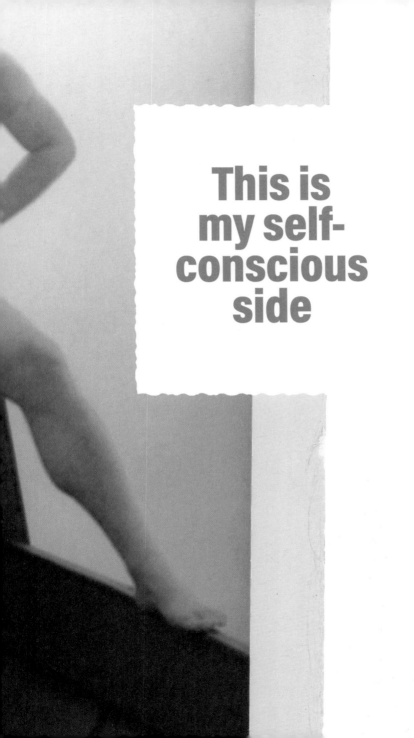

This is my self-conscious side

Its not very good Ray,
But its the only one
ive got right now.
Send me one of
you huh?
Actually, im very
beatyful. HaHa Anyway I
got my show of the
whistles in real life.

over

The protruding tummy with the first plate of cake is me.

7/4/47

10-8-62

Honey do I look
Fat in these
pictures? Remember
how much I love
you honey.
 True Love
 Your Husband
 Ronnie

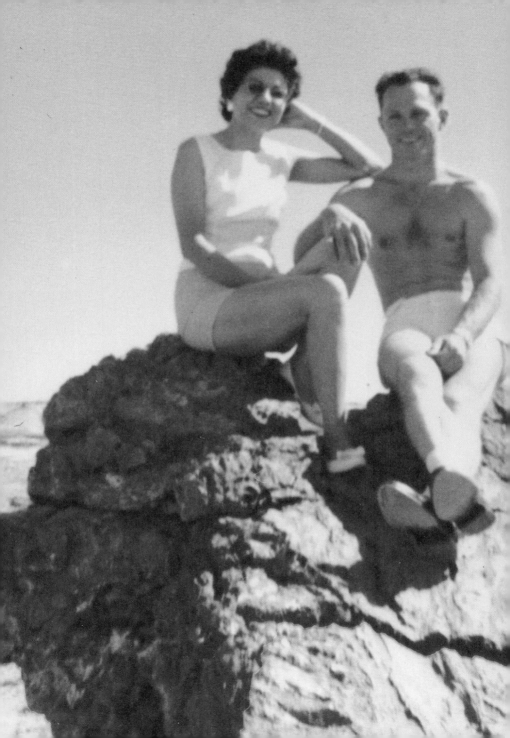

Mary & I sitting on
a big petrified tree.
I don't know weather the
tree or me. shows our
age more —

I hate this priesy
smile of mine but is
good of the rest of you.

me after a long day on the job. Boy do I look terrible. Hope you like it.

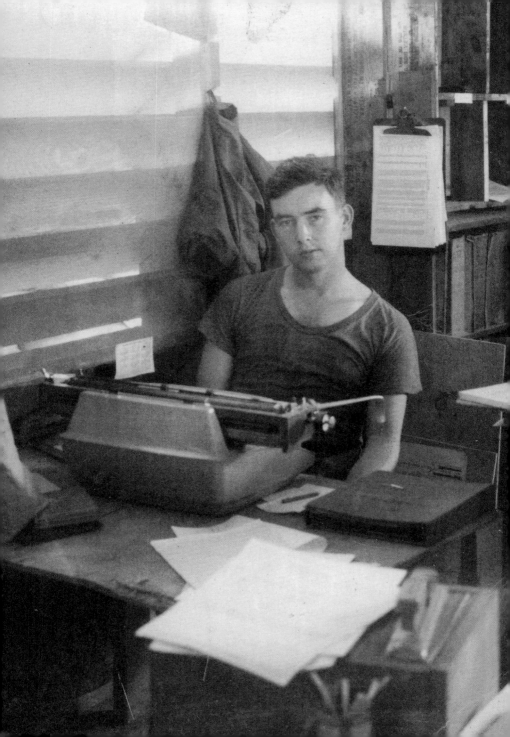

I always
spoil a
picture -

I know this is a poor
picture, but then I'm
no bargain either

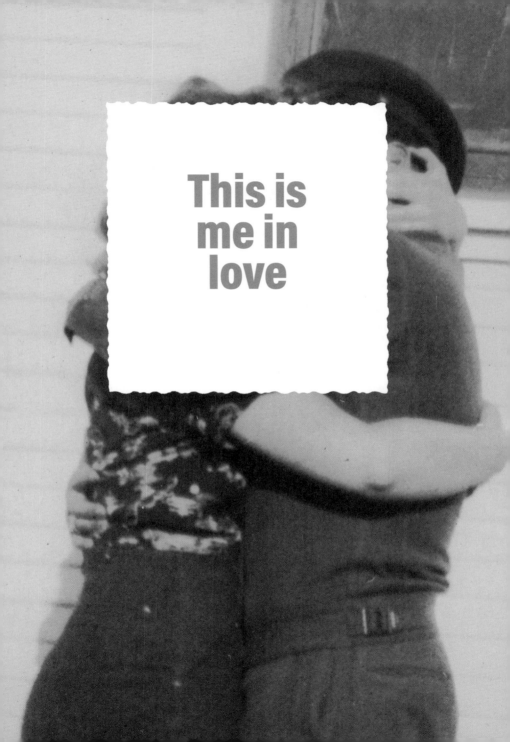

This is
me in
love

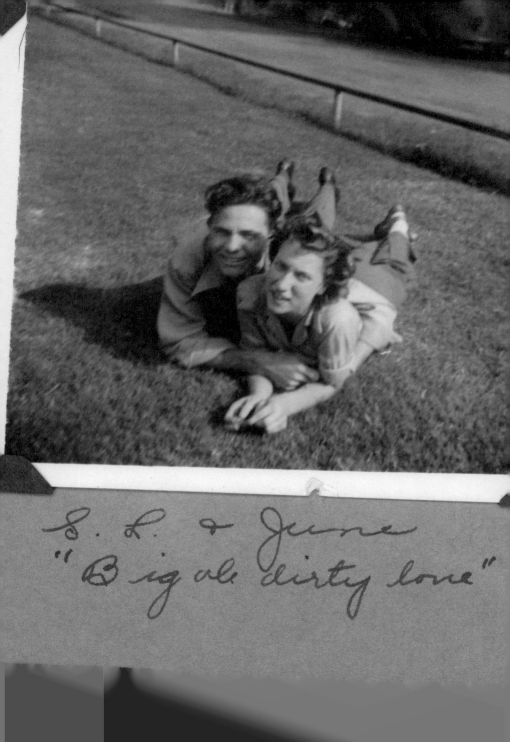

S. L. & June
"Big ole dirty love"

Ah, that's the way
I would like to be
all the time, only
the most important
one is missing, yes
you my darling. Plea
Please help me

complete this pict-
ure.

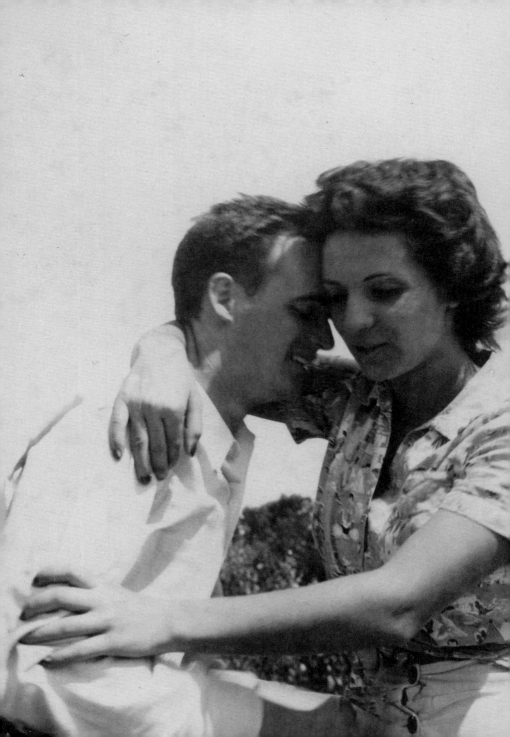

This looks
indecent!

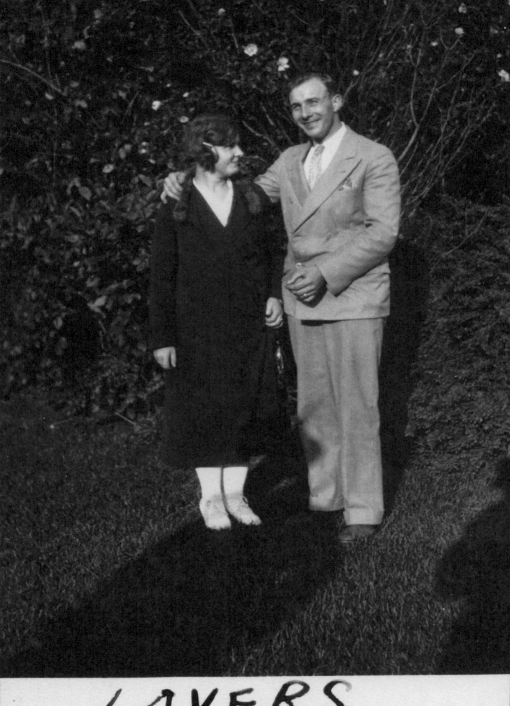

LOVERS

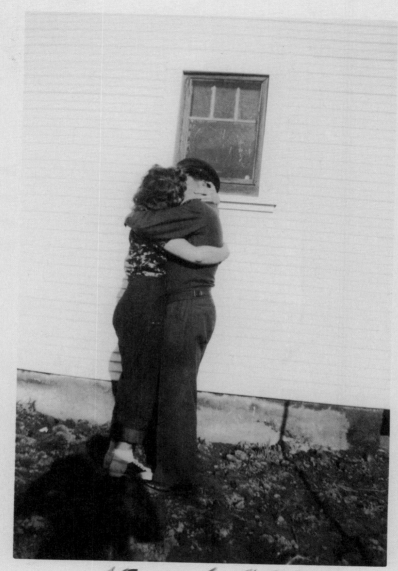

Strangle Hold

The shie

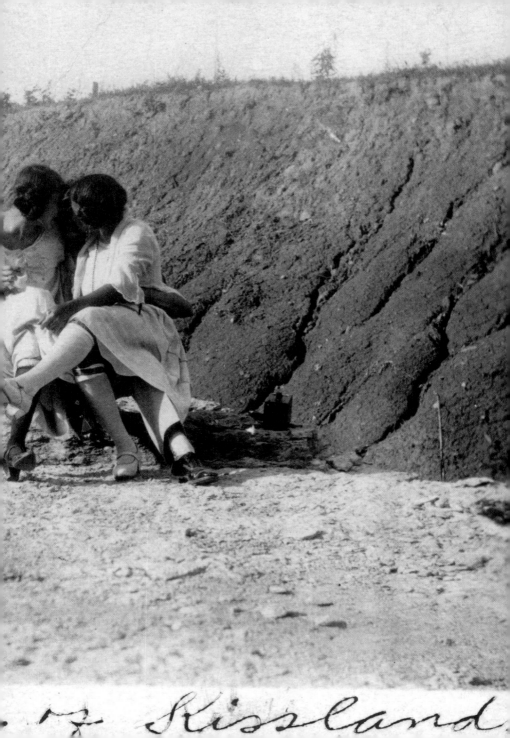

Kissland

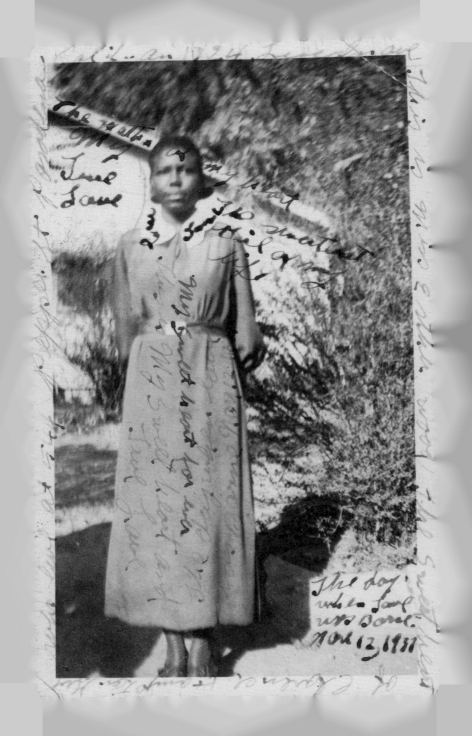

This is a letter read my intend wife our first born was on or around november 12, (1937) she has been a true girl to me. Every true, and by the help of i. hope.
GROWING ——
God.
She will all ways b?, our soul is growing deeper and deeper and we are setting founder and founder of each other every day, and i hope our engagement will follow in to marrige, here i will stop and ask God easy
help us through life hard path —
may - may our lord Straigt thicket
may our life be sweeter
may our best days be always i. H. GAY
; CLARENCE

NOT my N
good but
you may
fail my
heart with
it
fave
martin

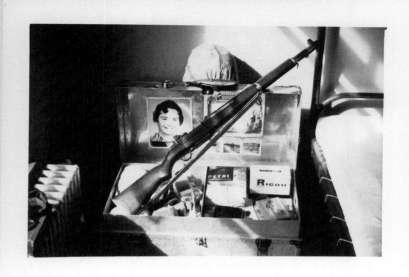

my girl,
my gun,
my helmet, +
my marriage lisens?

3 ₁

love ya.

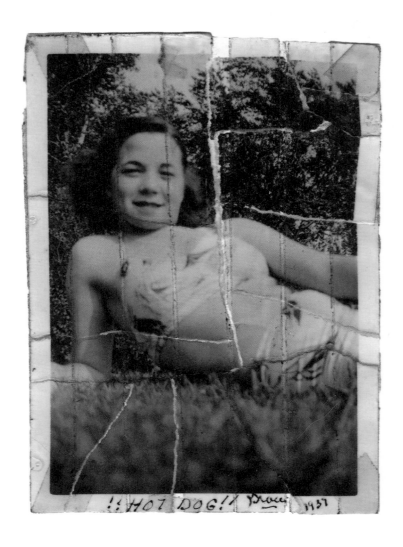

Aren't we a loving couple? I always was like that tho'

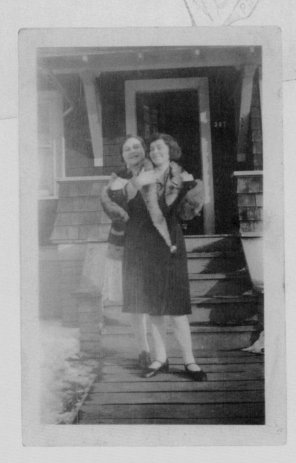

Don't say
984 a word.

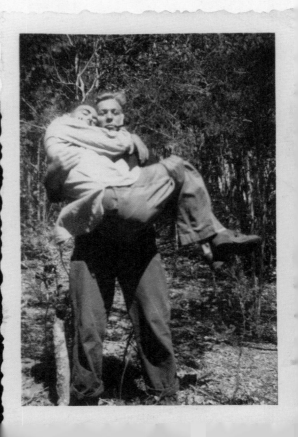

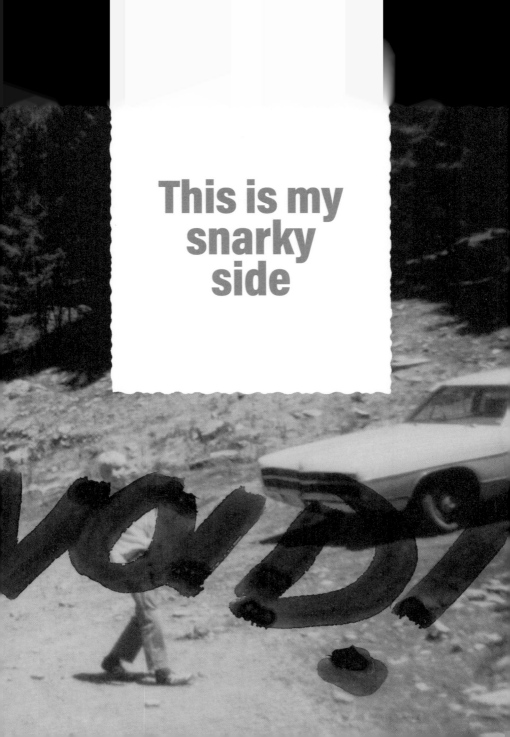

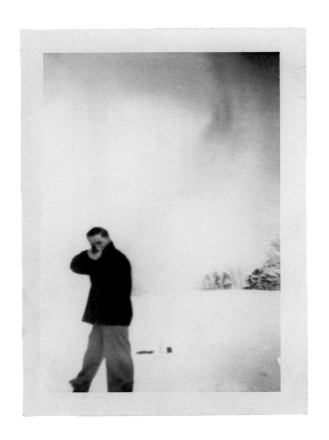

Jerk

THIS IS BARROW, OUR HALF ASSED
FIRST SERGEANT AND HIS
IDDIOT GIRL FRIEND

$ I WONDER HOW HIS WIFE AND
TWO KIDS WOULD LIKE TO
SEE THIS PICTURE
HE LIVES WITH THIS ONE LIKE
SHE WAS HIS WIFE

7/13/57

"Sexy bottle of gin."

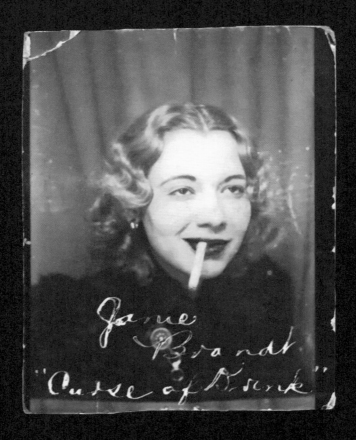

Jane Brandt
"Curse of Drink"

This guy is drunk

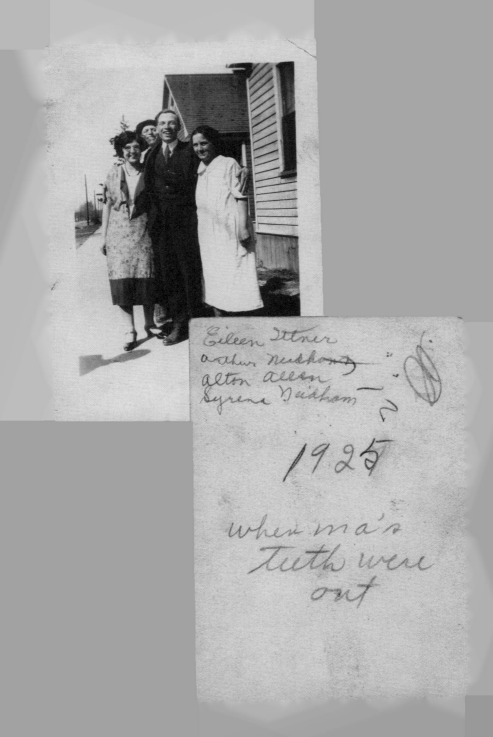

Eileen Ittner
arthur Needham
alton Allen
Syrena Needham

1925

when ma's
teeth were
out

Take It Or Leave It Feigenholzer
and his third wife

— DOING NOTHING
AS USUAL —

Heres the stuck up.
Zida

these was taken last
Summer

I would nt to show your
how fat Hazel is now

Charlie

Taken March 12 '44

Isn't he getting fat!

He says No he's not.

But look at him

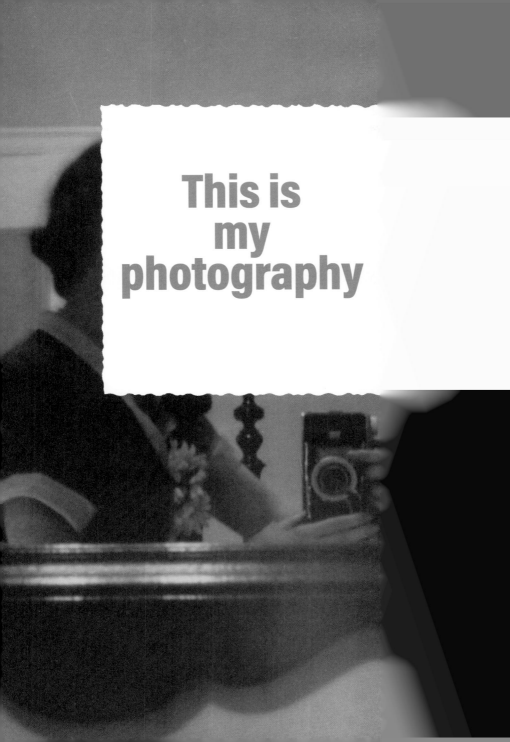

This is
my
photography

Time Exposure
in Room 232

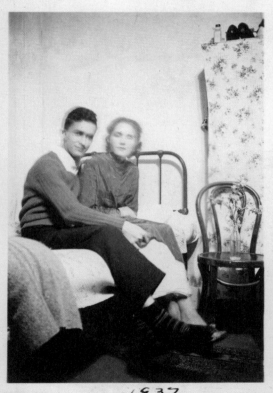

1937

Blank t.V. set, Because took a photo
and light reflected

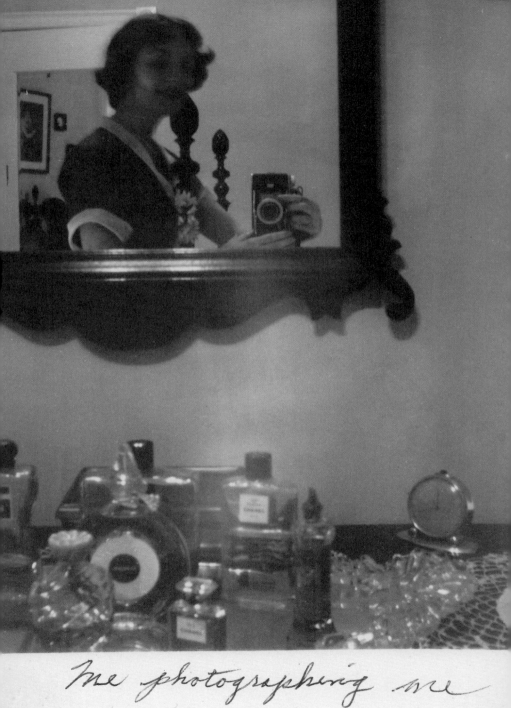

me photographing me

Babe says you were
fixing the camara .
when you took this
of yourself.
not bad Eh!

OSU June 3, 1939

LIGHT GOT IN CAMERA

How do you like this one?
truck Photography – get a half
doz. lamps from only me.

1 - 4 - 59

17 222

To my darling
Catherine —

Here is another of
my ugly pictures
I had taken a
few days ago.
The film was
no good at all
as you can se

"Fresh" picture.

Myself studying
Anatomy

Took this myself notice
string in left hand. It
was attached to camera

This is me out in the world

Looking at the world through a porthole

Nov '49

MARY "LEFT" & DORT "RIGHT"
using A LITTLE COOPERATION.

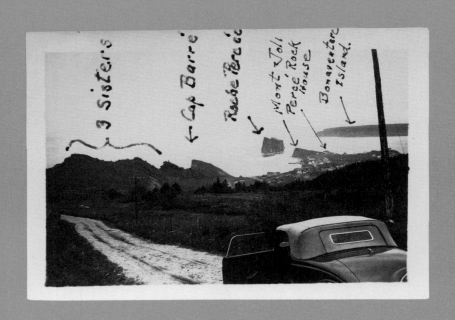

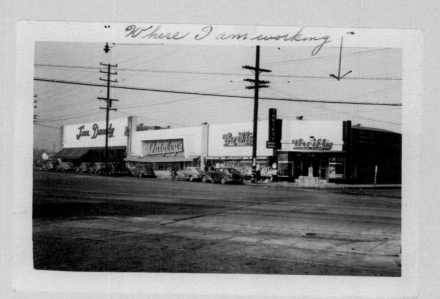

"Where I am working"

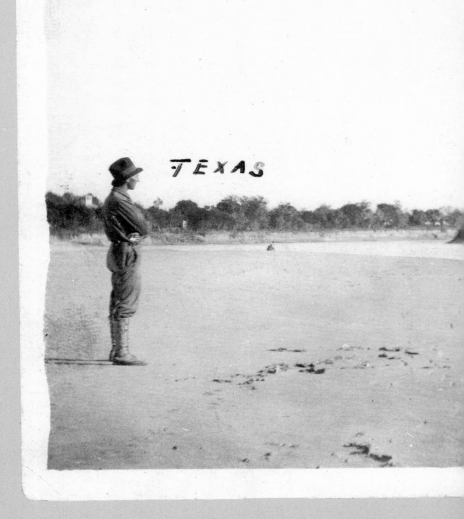

TEXAS

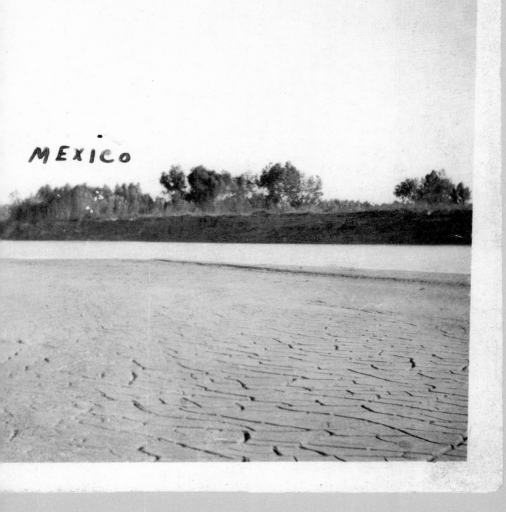

MEXICO

Ruby also at the Bay
undesided Wheather to
swim are drown
But we had
a nice
time

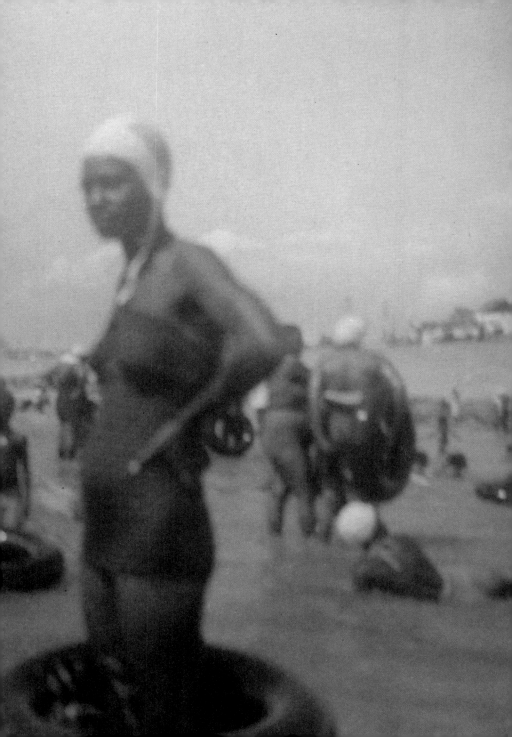

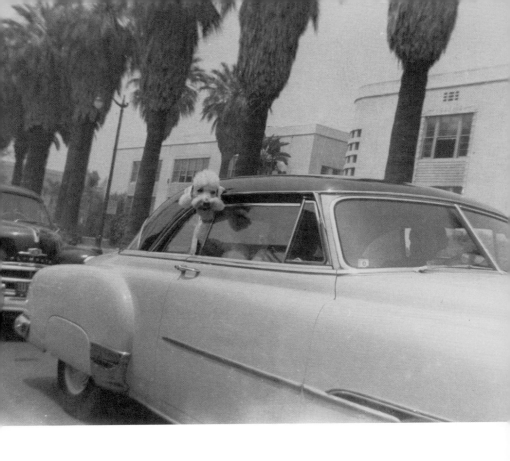

California type dog in Hollywood, Cal.
Aug. 1952

Looks like we were
mad at the world when
this was taken.

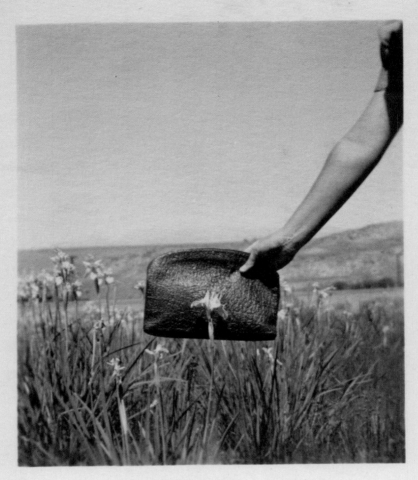

Field of Wild Iris

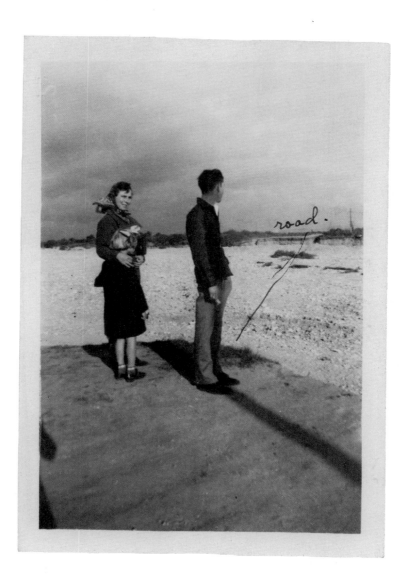

road.

Taken from our
hotel window
N. Y.

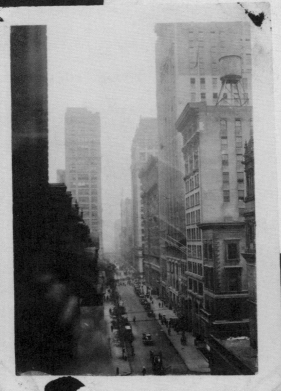

After London, this. Our suite
of rooms decorated as the
concierge would not like to see
it. Hotel Bedford, Paris.

Another of Big
Bear Lake. That's
the Sun making
the glow 7286#

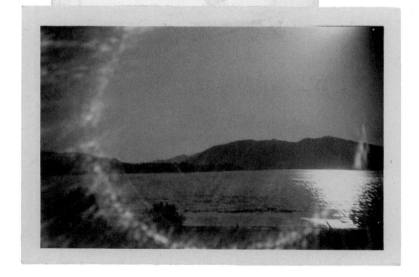

FISHBOAT IN SNOTTY SEAS

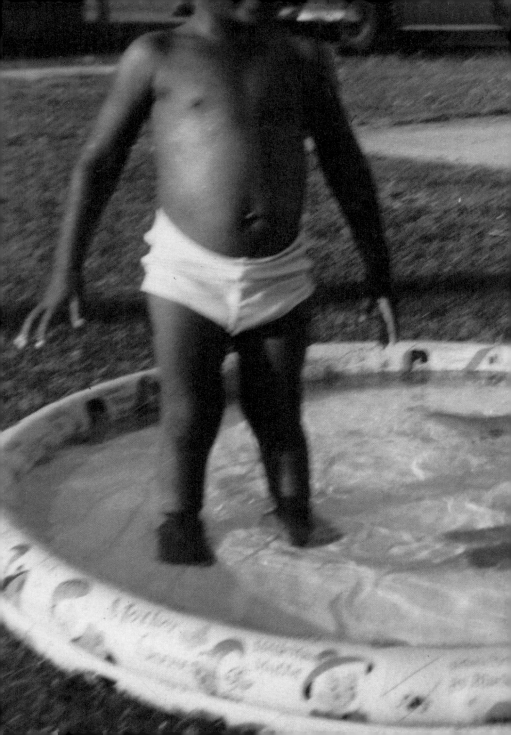

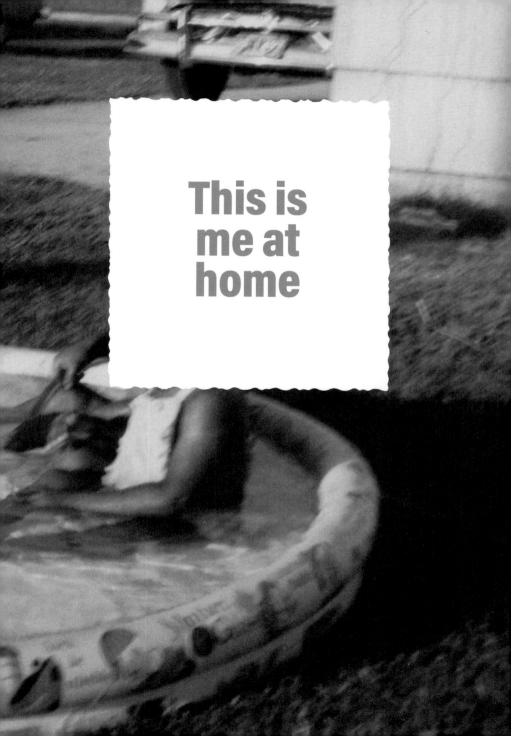

This is
me at
home

Front door

FEB · 64 ·

No. 1

The water had 5 inch
more to go before it would
be in the house. I hope I
will never have to go through anything
like this again
 Love + kisses
 Mom

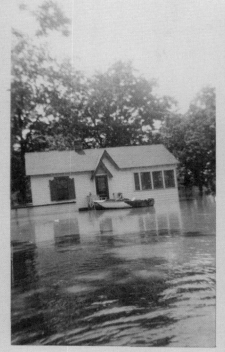

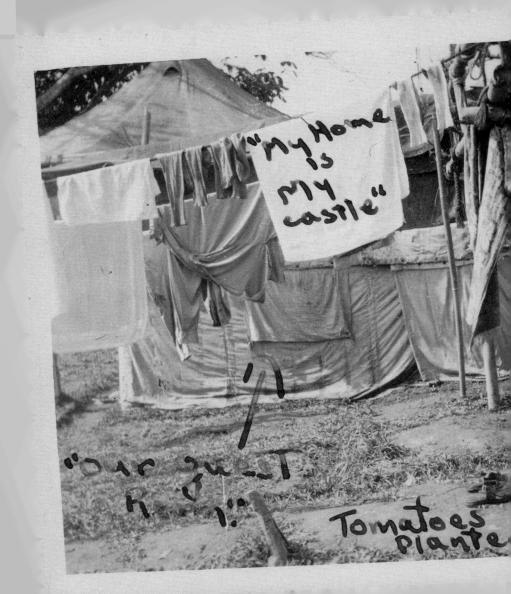

Here is a picture of me and Val we were mad
at each other when we took this picture, we
didn't have anyone to take the picture but
on Vals camera it has a minute timer so Val
set it then he hurried to sit down by me and
it took our picture this was about a week
 after val had his accident you can see
 his bandage

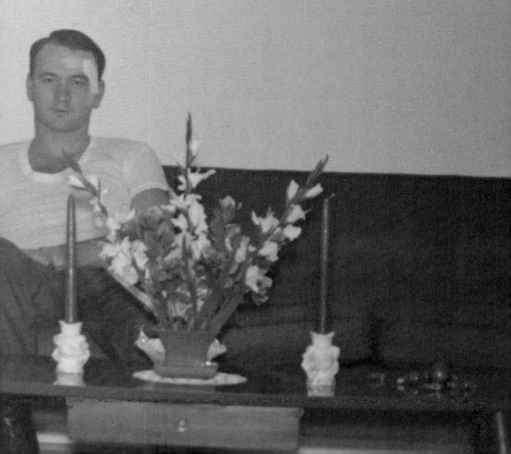

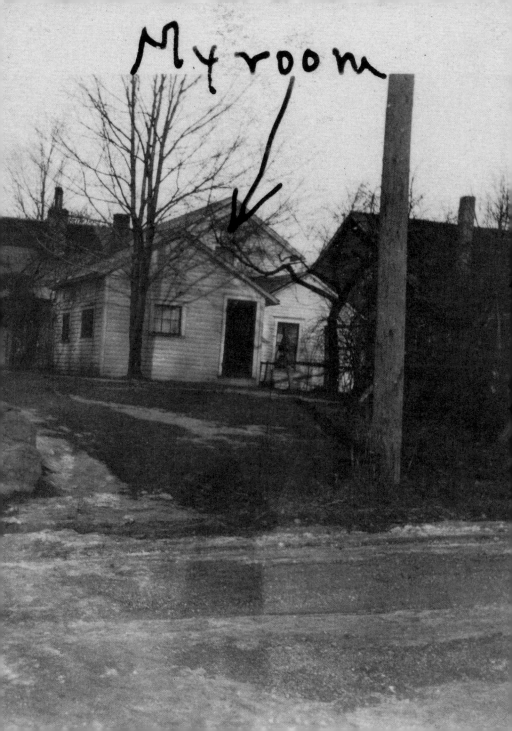

This is our house
Mamoma.

Here is a relaxed
moment in the afternoon

Your Boy David is
Something else (Smile)

This is what takes me to
work morning & through
re home rites
Do you wonder I'm
late some times

New Year's Day 1971
Ed with his mustash –
He shaved it off –
I think he looks
better with it.
As usual you can
see my kitchen is
in "apple pie" order.

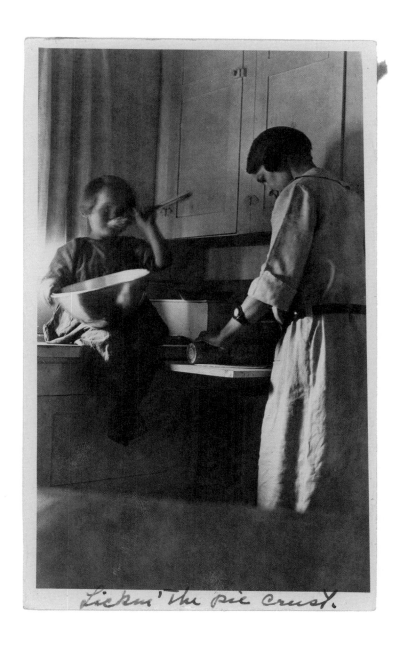

Lickin' the pie crust.

Emmet and Vera
in their home.
Dec. 27 - 1954.

Eating my
lunch

1954

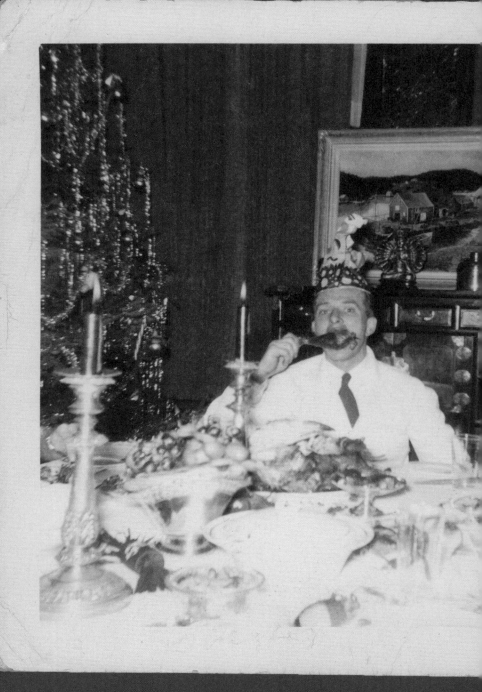

THIS WAS OUR YMAS DINNER
PARTY 1950
DOESN'T THE TABLE LOOK GOOD
NO WONDER WE'VE GAINED 10 LBS

" LINDOLA "
HALIFAX
CANADA 1950

Resisting Capture:
Capture:
The Counterculture of the Caption

KIM BEIL

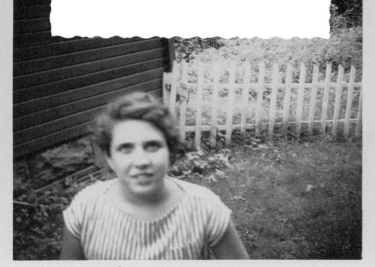

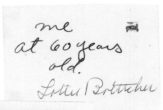

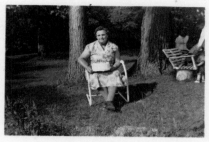

THIS IS ME.

 THIS IS IT—ME.

 THIS IS "ME."

 MYSELF. There's a whole cast of characters in these photographs. They may advertise a one-person show, but it's a play that features everyone, everywhere English is spoken. The captions all claim to be "me." But none of them are me. Probably none of them are you either. When you're reading handwritten text on a photograph, you inhabit two subject positions at once: you're you, but you're also "me."

In photographic captions, more information often points to more mystery. Who is "me"? In one snapshot, the answer arrives later, in red pen. "Me at 60 years old" was Lottie Brittcher sitting in a lawn chair, holding a layer cake crowded with candles. **(FIG 1)**

As soon as I know, I wish I didn't. The later addition of her full name seems to guarantee that she has celebrated her last birthday. Someone else translated Lottie's personal statement into the distant voice of the third person.

Etymologically, captions are meant to "capture," to arrest the meaning of an image by describing what is pictured and how viewers should interpret it. But just as often, especially in vernacular photographs, the caption also resists capture. These captions are conversations. They trade inside jokes, they tell stories, they speak in tongues. They refuse to explain themselves. They keep the image in motion.

Words and pictures have had a long and uneasy relationship. Around the year 15 BCE, the Roman poet Horace drew a parallel between the arts of painting and

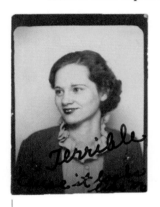

poetry. In his words: "Ut pictura poesis," or, "As is painting, so is poetry." The comparison also focused attention on the competition between these two modes of representing the world, later called the sister arts. The sibling rivalry is still felt when we read text and pictures together today. Often, the text seems to have the last word. Once we've read the descriptive text, it's hard to see the picture without the words in mind: "Terrible 'cause it looks like me." (FIG 2)

Although they were compared in ancient times, pictures and words haven't always gone together. Before widespread literacy, early modern popular prints had to be legible without words. Many depicted recognizable scenes, which viewers could then narrate on their own, recalling a Biblical story either silently to themselves or in conversation with others. It wasn't until the early sixteenth century that text was regularly added to a print: the name of the artist who created the original image, the engraver who carved it onto a printing plate or block, and the publisher who printed and disseminated it. These prints also included blank space below the image, which was reserved for additional text to be added later, whether lines of verse related to the image or a descriptive

2

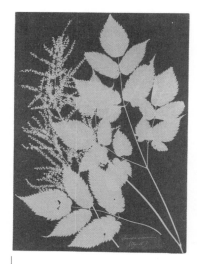

key, especially for prints that included many distinct personages or distant places.

These conventional uses of text were quickly adopted by photographers in the nineteenth century. As early as the 1840s, photographs were mounted onto hand-lettered or typeset pages and bound in books and albums. Anna Atkins included the names of plant specimens by hand-lettering titles on translucent paper and exposing them as photograms. **(FIG 3)**

3

Later, publishers of stereograph views used similar techniques for including titles and trademarks within printed images. **(FIG 4)** Other photographers scratched their titles into the emulsion on the negative plate. In 1848 Bartlett's *Dictionary of Americanisms* defined *caption* as the text "in the newspaper where an Englishman would say title, head, or heading." Newspapers and then magazines relied heavily on these short, descriptive texts to lead readers through the complications of text and image. Caption culture was born.

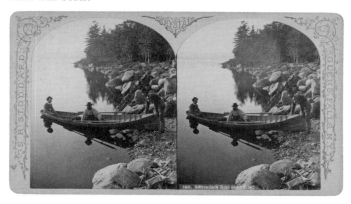

4

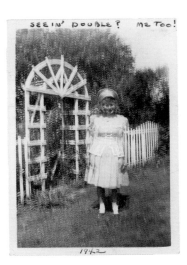

Until the 1890s, though, most photographs were produced by professional photographers. Cameras were too expensive and developing was too complicated for casual use. The release of the Kodak box camera in 1888, followed by the inexpensive Brownie in 1900, made photography accessible to amateurs. Images became more diverse and less serious. They showed more people, and people in more situations, than ever before. These photographs demanded captions. Many amateur captionwriters sought to explain the image: "This is a picture of ____." Or to excuse their technical failures as novice photographers: "Seein' double? Me too!" (FIG 5) Or, "Ethel and I 'beheaded.'" (FIG 6)

The sister arts were still best friends at the turn of the century. Halftone reproductions allowed photographs to be printed in newspapers alongside text for the first time in the 1890s. Color lithography was making increasingly elaborate prints available at low cost for a steadily expanding market. Some of these small prints were designed to go through the mail without an envelope. First called "private mailing cards," then renamed "post cards" in 1901, they borrowed many of the standards of earlier printed images, notably the blank space left below the image for a short handwritten message. Soon postcards were also being made photographically. In 1903, Kodak released a new camera, the #3A Folding Pocket Camera, designed for postcard-sized film. Until 1907, when the postal service began allowing writing on the back of the card, handwritten messages were restricted to the picture side. Postcard writers crammed their messages into the

KODACOLOR PRINT

Made by

SEPT. 64 P — Kodak

Ethel & I
"beheaded" at
Wynns Beach
House

small space around the image, sometimes saying no more than "Meet me here" or "Will write later."

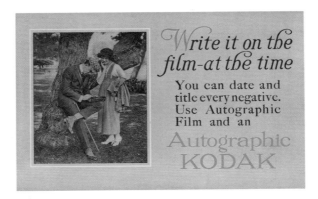

Write it on the
film-at the time
You can date and
title every negative.
Use Autographic
Film and an

Autographic
KODAK

Camera manufacturers created still more new products to meet the demand for combining text and image. (FIG 7) The Kodak Autographic camera, first sold in 1914, was designed for film that left space for note-taking on the image. By writing on a slip of carbon paper loaded between the negative and its paper backing, then opening a hatch in the back of the camera, photographers could include handwritten notes on the negative. Kodak designed the Autographic for recording date and location details, that most basic information that an image on its own can rarely verify.

Newspapers also began sponsoring caption contests to expand and engage their readership. In 1913, a newspaper in Calumet, Michigan, offered a free six-month subscription to the writer of the best caption for a photograph titled "What is Uncle Sam Saying?" The *San Francisco Call* promised twenty dollars to the writer of the "cleverest title" for a series of 1912 illustrations. Advertisers soon followed suit. In 1920, the tire company B. F. Goodrich proffered a first prize of one hundred dollars in gold for a caption to accompany a Norman Rockwell illustration of three boys on bicycles. The Goodrich

ad men wrote: "A title for this bang-up picture is wanted and wanted bad, and only boys can help out." Every boy who entered the contest would receive a color reproduction of the illustration.

THE INTEGRATION of text and image increased exponentially in the 1930s following the rise of the picture magazines *Life* and *Look* in the United States. According to the Google Ngram Viewer, which tracks the appearance of words in print volumes digitized by Google, the use of the word *caption* reached an all-time high in 1941. The visual-textual hybrid of the caption was by then in wide use. It had escaped the bounds of professional publications. In 1935 Kodak's popular instructional handbook, *How to Make Good Pictures,* began advising that amateurs add captions to their snapshots. For pictures of children, Kodak suggested making a series of photos to accompany popular nursery rhymes, such as "One, Two, Buckle My Shoe." Other storytelling pictures, such as a sequence illustrating the five senses, were also popular recommendations.

A caption craze swept the United States in the 1950s and 1960s, part of what historians of consumer culture refer to as the contest era. The occasional newspaper caption contests of the early twentieth century swelled into an entire industry by midcentury. Advertisers called on the public to generate slogans, write jingles, and provide photos to sell products in an early instantiation of crowdsourcing. Kleinert's, the diaper company, advertised a baby photo caption contest in *Life* in 1952, asking: "Got a cute baby? Got a cute idea? Take a photo! Write a line! Win cash!" (FIG 8) The samples included a grinning baby girl with the first-person caption: "How could they have considered anyone else as Kleinert's cover girl?" Or, punning on a baby doing a headstand: "These days it's hard to make both ends meet."

Captions were increasingly at odds with the image. They didn't just describe the photograph; they offered an alternate interpretation. Today a talking dog, as in

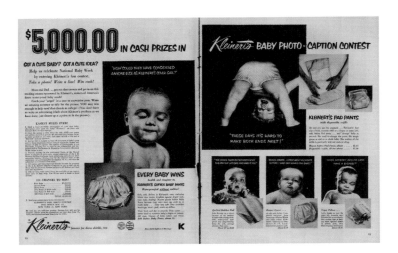

Kodak's suggested caption "They Named Me Rover," is hardly surprising. But a century ago, combining the fantasy of words with the supposed fact of a photograph represented a radical new take on the text-image relationship. In the seventeenth century, the word *caption* referred to an arrest by judicial process, according to the *Oxford English Dictionary.* This origin in legal discourse imbued captions with the aura of unimpeachable fact. By the middle of the twentieth century, though, they were exhibiting a distinctly countercultural bent, undermining both the image and the text. As in many other areas of culture, captions also became a place to challenge convention. The more these captions tell you, the less you can be sure that they're telling the truth.

As image-text opportunities grew, both in public contests and in private pictures, captions became less serious and more insouciant. Contemporary language and wordplay started appearing in the staid Kodak handbooks. "Mom helps Judy swing it," is the sample caption for a picture of a child on a swing. Other Kodak captions hinted at larger stories, such as a photo of three women pushing a boat: "Not all clear sailing." One book, published in 1959, even imagined alternate captions for famous works of art. In *Captions Courageous,* satirists

Bob Reisner and Hal Kapplow let James Abbott McNeill Whistler's mother speak back from her famous profile portrait: "When's that no-good son of mine gonna send the rent money?" Here the competition between the sister arts is fierce. Words will never let you see Whistler's somber mother in the same way again.

THE POPULARITY of caption contests peaked again in 2010, coincident with the explosion of meme culture and the launch of Instagram, both media predicated on the image-text relationship. Instagram invited users to caption all of their photographs with text. Like earlier captions, these initially took the form of explaining the picture and, sometimes, verifying the photographer's skill or the beauty of the original scene, as with the hashtag #nofilter. Elsewhere on the internet, the image-text relationship was less earnest. In memes, like in the humorous captions of the contest era, dramatic irony prevailed. LOLcats and Grumpy Cat memes anthropomorphized feline photos, giving cats the naïve or jaded voices that have since become synonymous with internet culture of the early 2000s. Making memes in the earliest years of the phenomenon required that users have image editing software, such as Photoshop, in order to place text on top of an image. The launch of the site memegenerator.net soon made the practice accessible to anyone with an internet connection and a sense of humor. Users simply select an image, then add words in one of two boxes labeled "top text" and "bottom text."

As the pictures in this book prove, however, the playful, challenging relationship between text and image was established long before the arrival of the internet. Countercultural captions challenged the supposed truth of both photographs and words. Traditionally captions relied on a tenuous circular logic: the picture proved the text, while the text proved the picture. But all it takes is one caption to disrupt the equilibrium. "This is not me," reads the text above a photograph of a cowboy, suddenly destabilizing all the other statements in the book. (FIG 9)

Why should we believe any one of them?

Especially in found photographs, separated from their original owners and recontextualized, the shared knowledge that caption writers once relied upon has disappeared. Neither the text nor the image can be verified. Reasonable doubt brings the whole operation into question. Although the root of the word suggests that captions should be able to pin down or "capture" the meaning of an image, in popular practice they can also set the image free.

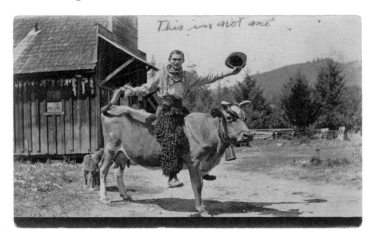

ACKNOWLEDGMENTS

Thanks to Jennifer Thompson, Sara Bader, Peter L. Stein, Martin Venezky and Kim Beil for your unfettered enthusiasm, love of words and pictures, invaluable research, keen eye, and appreciation of histories both big and small.

BARBARA LEVINE and **PAIGE RAMEY** are artists who collect vintage found photographs and archivists who curate. Their extensive archive, projectb.com, is dedicated to sharing and preserving vintage vernacular photography. Levine is the author of *People Kissing: A Century of Photographs* (with Paige Ramey, 2019), *People Fishing: A Century of Photographs* (with Paige Ramey, 2018), *People Knitting: A Century of Photographs* (2016), *Finding Frida Kahlo* (2009), *Around the World: The Grand Tour in Photo Albums* (2007), and *Snapshot Chronicles: Inventing the American Photo Album* (2006); all were published by Princeton Architectural Press.

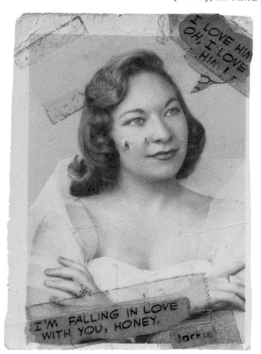

IMAGE CREDITS

Images on pages 11, 21, 24, 27, 66, 82, 87, 88, 98, 102, 107, 113, 114, 120, 123, 127, 128, 130, 132,136, 138, 141, 155, 158, 176: The Museum of Fine Arts, Houston, Barbara Levine and Paige Ramey Collection, museum purchase funded by the Caroline Wiess Law Accessions Endowment Fund. All other images from the private collection of Barbara Levine and Paige Ramey.

1938

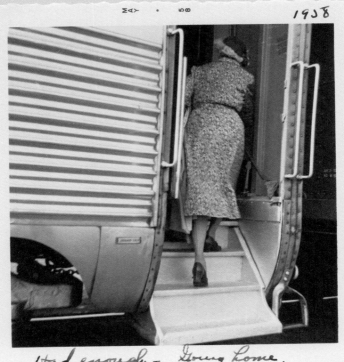

Had enough - Going home.

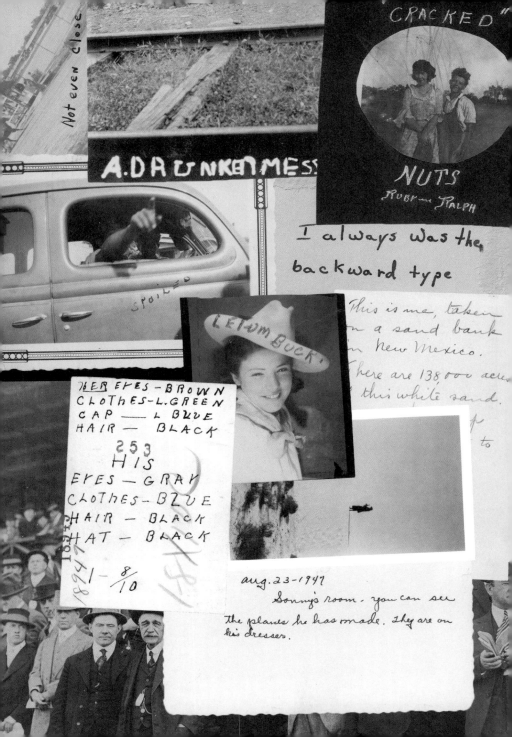

Not even close

"CRACKED"

NUTS
Robert Ralph

A. DRUNKEN MESS!

SPOILED

I always was the
backward type

LET'UM BUCK.

This is me, taken
on a sand bank
in New Mexico.
There are 138,000 acres
of this white sand.

to

HER EYES - BROWN
CLOTHES - L. GREEN
CAP — L. BLUE
HAIR — BLACK
253
HIS
EYES — GRAY
CLOTHES - BLUE
HAIR — BLACK
HAT — BLACK
1 - 8/10

aug. 23 - 1947
Sonny's room - you can see
the planes he has made. They are on
his dresser.